NOUS

D1545888

JOSEPH HARMS

IFSF PUBLISHING

SAN FRANCISCO

FIRST EDITION
ISBN: 978-1-7333864-6-3

Published by IFSF Publishing
San Francisco, California
www.ifsfpublishing.com

Poems from *Nous* first appeared in *The Opiate, Bayou Magazine, Hamilton Stone Review, The Gravity of the Thing, Leveler, Floor Plan Journal, Quail Bel Magazine, Vector Press, Radius: Poetry from the Center to the Edge.*

Cover Art: *Fire Jottings,* from a poem by Tomas Transtromer, oil and acrylic on canvas, 28" X 22", Copyright © 2019 by Brooks Roddan

Interior Art: *Wormwrit Trunks #1-5*, oil on canvas, 14" X 11", Copyright © 2020 by C. Winn Mahoney

Book Design by Joseph Harms

In *Nous,* Joseph Harms introduces us to a language and a vision for which we've waited—a daring cave-dive of an exploration into the ways words might make the world tangible, while elusively psychological. Here, the hot wire of the subconscious touches the live wire of human experience. Each poem is a spell, a charm. Wild with words, like Dylan Thomas, but as careful in craft as any great poet has ever been. This is not poetry for the timid. There are magical incantations here, hallucinatory evocations of ordinary experience that will change the way a reader sees and thinks, hears and wonders. This poet's work transcends, with music and image, our human existence. Harms is an alchemist, a soothsayer, a songwriter and a healer. *Nous* is hypnotic, mystical. Read these poems aloud and you will find yourself transported to a realm in which mere syllables deliver an electric shock, and whole poems deliver endless aftershocks. This is poetry written from its most mind-bending heights and supernaturally darkest depths. You've not read a book like this before. You'll return to it, as I have, again and again, for the thrill-ride's shiver and for the deep recognition of truths that have stayed waiting, buried beneath secrets: here you will find your secrets hidden in the disguises of their truths—truths this poet reveals for us, delivers to us from the depths, returning them to us with the most ruthless sort of compassion: which is poetry.

Laura Kasischke

Joseph Harms is one of those rare poets who is truly inventing his own language. His poems are thickly populated sonic events that manage to plumb existential depths in weirdly ordinary settings. Most of all, it's clear that this is a poet who loves—I mean *loves*—words. I've never read anything like Harms' work; each time I encounter it, I emerge with better questions, wilder memories, and a fiercer devotion to all that poetic language can do.

Franny Choi

Singularity—as George Oppen put it, *If a poem is a poem it could only have been that poem*—is the special territory of the poem and the poet. The writer of a poem reorders a reader's relationship with time as if time never existed and that it could last forever. It is while we are in this territory, rare as it might be, that language itself becomes a kind of theatre and the reader becomes part of the creation of the scenes, the actual action of the drama—"heading to town to fuck shit up...// to call this sky a monster worth the worship"—so that there seems to be no distance at all between the obvious and the obscure. It is also worth noting how many poems in this book are launched poetically and yet dock prosaically in the language of our time.

Such a poet may best be read aloud; for hearing the poems aloud the reader can't help but be immersed in language the way one is immersed, for instance, when hearing Old English—to be carried along by the language alone, hearing more clearly perhaps the interior and exterior monologues in each poem as they are speaking to one another.

Nous is a book that is sending a special invitation to the reader as both reader *and* listener—that sometimes a book may be read in a way that conveys something close to pure information.

Brooks Roddan

AZAZEL & BEL / 7

AZAZEL & BEL

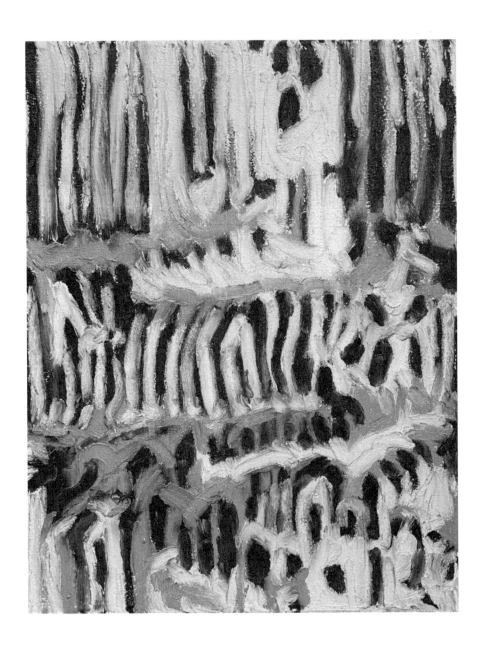

THE RILL

Winterbourne and foiled black by snow,
cinereous forest, a cardinal's miracle. Bones
like light, as friable, rebus the matted
moted ferrous leaves and hulled branches cancellous
as bones, some writ by deertooth worm and beak.
We'd take the philter here when possible
and headtotoe atop the frozen rill
we'd buzz as whole as we would ever be,
both umbra and antumbra, warm and meek
like Jesuses beneath the falling snow
and perfectly emotively cold and plumed,
how Cain tries Able front of mirrors icicled
in rooms libraried throughout this evil evil
world thrilled to be the other, entreats sotto
as if from there to hell: Please, sinner, eat us
for us; warm us by your ingle's manic wings.
We would have lain abreast had there been room.

HELOTS

When witchinghour engines'd rattle our
prefab quondam houses, searchlights in
the lotic dark before the sharpening woods'
enisling shiver in response the stars
prepense, we knew we'd wake an hour early,
reaped cornscintillae in the dawn above
the leaves' hegira from wherever one
might look, streetlights against a sun uncapsized,
the summer's cacoethes gone a sudden.
You'd come to me before your cachalots
arrived to drive you to highschool and give
the needs they'd soon replenish (evercuffed
our sleeves) as quoins dehisced and dams undammed
in Helots' Ensile (replaced a lustrum
down by Hell's Islands much the worse). I'd see
the train in your eyes and you in mine and
we'd only touch where a thousand angels stood
dumb to how great the leaves sounded as
they involuted, how whispers must soon rattle.

SUASORIA

I make nulliparous my women for
you, Bel (too sad to watch pretended choice).
Each to each I'll never leave: I owe that.
Most trees that grow with youth seem small returned
to, growth done. Yeaned we were. The L where's it?
Belial and Azazel: you must know
this. Orcuspast gorgoned beneath a fuch-
sin sky amerces phony moonward plaints
as just, hulls nonpareil tendered atemps.

Sehnsucht ru(i)n(e)s love.

Art ru(i)n(e)s love.

I knew such hope. You did not.

It takes Iago and Othello to make Satan.

UNTRUSSED

He watched himself as one'd a foe, at best
a corvine snowed, where flake and vane meet
awake at times to scop the foresttop
alluvia (the phatic all): Oh, fey
heart of this and that! oh, gay old sometime!
the thinnest know, untether hunger wonderful. /
The aqueduct that rachises from holt
to holt (the Huroned towns subjacent) top which
the leaves will undecide their scribe deposed
while men unjob(b)ed rakecull sigils (their Sunkist-
killall coldgrilled, cinderblocked) their thruway
toward what dreams when spoke are haunted halt
like jaysent robins 'fraid, untreed, or hawks
when corvinerankled. Here on colubrine
halloweened col where deer won't run when whispered
to and fathomed chimneys plait leaffall (their
ciphered intercourse disearnable) the two
until they're through unspoken shouldertouch
as if on accident within the vat-
ic all (the cursived sparrows galed). Sighs
of fur dislimn among blackcurrants
etiolate rathe by hoars (those near the earth);
on rocks exudate, berries forced and blood's
sure drapetomania; like gullleft gurry
the slabbed oblation (how unpacked, just left): the X
they ate their folks refused in gulletstrictures
fans the paradox of fused wishbones.

SFUMATO or CLEANLY WANTONNESS

We came to Nones too quick and so indulged
to leave the doledays when unGored from shambles
we'd journey biked then carred to Chelsea's silos
defunct where tracks cut woodward, hawks drop turtles;
rescript received dissembled we'd pretend
the day spent apart weren't so and pax the High Lifes,
the bodies spentthrough as if over for Goood.

The fear the buds on limbs brought even then,
a marionette's fear of perfection:
your nail down happytrails, my ponytailed
blasphemies; compromise sought got and spent;
we couldn't stop and can't (I know you, Bel,
my trigon: trust in Nonce, all else to punt;
pay or leave is daytoday in Peor).

Coccid to coccid: Less'ning love preserves
a love unrarefied, accountable:
we thought we might...it's not for us. We week
by week through years have hurt and love the same
with hate ingenuously spent: what's limned
is gone; the two the same confused firing...
We steam our vegetables incredulous, starved.

(Our ferriswheel thralls to each unknown) we
are still right there together at the fence
between I-94 and fairgrounds, jokes
birdshot for once. How we approached the fence
afraid to touch the links and not...as dust
into our hair sawed. (Never drunk enough
for this) we cried and sat back down alone
the more for love's like exile.

RACHMANINOV'S LONE TRUMPET

It is not the language of your tribe, all of whose members resolutely shun the roads that lead to death and tread only the roads that lead to life...White Logic, the argent messenger of truth beyond truth, the antithesis of life, cruel and bleak as interstellar space, pulseless and frozen as absolute zero, dazzling with the frost of irrefragable logic and unforgettable fact...will not let the dreamer dream, the liver live...destroys birth and death, dissipates to mist the paradox of being...whispers...Life lies in order to live. Life is a perpetual lie-telling process. Life is a mad dance in the domain of flux, wherein appearances in mighty tides ebb and flow, chained to the wheels of moons beyond our ken. Appearances are ghosts. Life is ghost land...You are an appearance...All an appearance can know is an image. You know mirages of desire. These very mirages are the unthinkable and incalculable congeries of appearances...Life is apparitional, and passes. You are an apparition...you rose gibbering from the evolutionary mire, and gibbering you will pass on, interfusing, permeating the procession of apparitions that will succeed you. You are at any moment what you are thinking at that moment. Your I is both subject and object; it predicates things of itself and is the things predicated. The thinker is the thought, the knower is what is known, the possessor is the things possessed.
Jack London

Not love repined but magic never had
augmented palled estranged his days: the muse
extant demands alterity and praise.
When gone White Logic autogams the falc-
ate rheol, resolve of apophens; the ruth
usurping better served by irrealing;
the mornings trephinate; the stygian sun
a bagnio a rubicon a scutch
a hant a henbane, mortish circum-
incession (raining jackdaws, fallow field,
the earthend watertowers godding, moths'
wassail from pooled swags, a Midwest road,
a smalltown graveyard's sycamores the first to bare);
the second reason for fey lines; verprevar:
people'd look at him and hug each other.

TARE

An afternoon in Iowa Az reattached
a tractortire to frayed rope by sandhillcranes
watched from some river, barns collapsing within
earshot, then drove on to what'd be next.
Somewhere cornfieldy, clean for weeks bar booze,
between Detroit and Manhattan where Az
was said to copshootcop his days,
Bel tugging pelt from grill removed the both,
contoured to radiator the heart, the body gone.

Contrails at dusk from separate rooftops
in Brooklyn both decipher long apart
and done with searching. Theatercurtains
close each eve, thank God, the message the same:
Go home, at least in sleep where wraiths exist
and torment makes some sense: his peri
her scab alive again; the horsetoothed dads
and couchant oozing moms; the way he'd die
midsentence, she'd leave for good so often so much...

To doss forever; tawse in dreams again
applied; fordone each turn each town; the morts
are heard when listened for; the morts the days
apart, so long so far, for Bel for Az
who turbidite, the minutes like unspent
shot inclined, otiose, an acciacc
their rarified presence among the civil;
the tare subtracted and the tare dayout:
the tare the tare accounted for:
We lose what we contain, my awful twin.

ANHEDONIA & MYSTICAL EXPERIENCES

The slash of powerlines adust and saccharine,
a mell of hay at root still vernal and
the seminal forest through which it runs,
the scent of dandelionstems, the sun,
the noumenon, grasshoppers hooked tailtotail,
one the other's birth, faraway eidetics known
so then: the surd the start the end, but this
our epoch, dandelionstem each end
in teeth, green scape before the oniony root

the golden chute, was Bethel, where we stood
in ken of shore assoiled every moment
the bethel, torquated spicaed trekking slashes
keloidal under horrent stars in dreams, each star
the versal lodestar, each our apogee.

Before and after routine pain the world makes sense;
in pain's immediate absence the noumenon
arises as before it comes it does:
not pleasure's loss but pain's the problem now
we're junked to kingdomcome, my love:
I've smoked too much to smell;
I've bled straight through
my mattress while dreaming
I was fine.

NOSTALGIA: LIFE BEFORE SEX

Reduced to toiles hardly mobile, springed
longside the furbelow lown cherrytree at April's end,
the moony death belittled now by porcelain
and rosy petals disembodied and
the poikilos treelight like what a light
heart gives, Az finally moved; he knelt then held
an ear to sun and read the map. Bel emptied
a paper shoppingbag of vodkapint
cigcarton scratchoffs coldcuts whitebread cannedcheese,
her mom's appurtenances, and with Az
began collecting fur and bits at foil's end,
dogtag within a petaldressed pile
more bile than meat unneeded confirmation.
The petals all a sudden riveled so

Az kneeled low and cleaned his hands with dirt
as Bel folded the paper lips upon
themselves and headed toward the river, eyes on
the long side of the photocopied moon
that looked as blue as day, as ambitted,
broke lighterhead and doused the bag then waited
for Az who soon arrived and lit the ship
and pushing said, I hope to go likewise:
killed by animals more beautiful than I...
The lantern went to where the poor selling
portents and nostrums and produce from poortents
were setting up for Friday's market and
was seen by none, no foil to the sun.
The kyotes stirred when by their valebourne it went out.

TEMENOS

Ascript's aition chez epact where tembl-
lors knell the pale's campanile and
a tree leviathan in dreams recalls
recalls the temenos of natal del-
iquescence; haunt his own hapax; to read
beneath the deertoothed laminae the ciphe
of hunger left by worms with certainty;
the tetramorphic sun elop(e)s as cant-
on levin balls (always a storm just north);
it's twilight all the time, an eglomise
this offing never left where peristyle
the clouds from shore: In Situs can't live here;
'Heres dealate, deracinate, can't leave
no matter if they've never been or will.

APORIA IIIII IIIII IIIII

They say he has a childsized mattress back
there covered in popsiclestains. And where'd
he get that nazimarch loop from? Bel asked.
He puts it in their faces and they still
let their kids buy Screwballs and Supermans
from him. Az lifted halterstrap to collarbone:
Bel's shoulder leapt as if horseflyed; her eyes
rebarbed then estivated once again.
Neither noticed the Main Street bench they sat
was tacky still with green paint as to stay
awake they stomacheddown icéd espressos

while fathers dadded and moms dammed and everything
was ending as when the periphery
is caught headon in halters and embossed
mares offing waiting for the homes
to sleep beneath the buzz of lamps that make
of them each a tenebrous beast stroked by elms
and beeches, oaks and pines, to stay the wake
that comes each dawn as halters lower limpid
as stars and lampreys steal among the hooves
to be eclipsed by porticos of mushroomclouds
and chimneysmoke. Again focused Bel extended

a tapping finger toward the icecreamman
as if counting his lupine teeth. He looked
then looked away then looked again, rebarred
his mouth with stache, turned up the march and passed.
Bel touched a track she called her puddle's leash
and tended to the sebum. Pregnant and
aborted flags heartbet above their heads.
A block down children swarmed the van that'd lead
to this: for her for her for her for her
a pop a cup a squeeze a cone that'd leak down wrist
and sticky in the crook where it'd be named before long.

ADOLFIC FAULTS
for Corey Eastwood

In Bel's bricolaged cote a collop on the molding straw,
of dole a foison in a scrap: how Thammuz turns
to Mulciber too late, Bellerophon bellonas.
So too with Az though aerie. Defalcated sky
a sign they're near, decade or more apart these days.
Adults don't hope; they quiet love and concretize
the future now: Az. They can laugh sans mirth, a word
I thought meant bitterness until my thirtieth:
Bel. They indulge so little, praise so much and kill...

In Accaron the afer windrows sanative
napkins against phlebitic shins unfilial
awful and needful, phonebooths where the shanties end
to call up ghosts for dimes; the most of fun is made
when stapled poles' aecium and syrup enchrist
a block long for the diaphane apophens' birthdays.
She would no more novate than he though she first stopped
here. What of sojourns never leaves both know. Always
morrow's fuel today's aporia; today's

impasse the morrow's spark: taut this, inhered. Uraeus-
sun; needed bird to 'hume the sky alack; the words
Repine demands in praise, the When the After: Bel
at times a street will stop auguring all unbirthed
as awnings quicken, trees unnet our memoranda
and snakes unflatten; Az his opened forearm Dis-
believes and sets to tying as is rote then Ruth
Israel chthonically to wait dehisced...assigned...alloyed.
A home for adulterant preterists is needed though likely
we've failed too hard for even this.

ANTINOMIAN

He washed his windows often, liked them fogged:
how analgeses anaphyl and lust-
rums will nychthem; sodality's enjoin-
ment reified each day, too aporets
(the mesic manches sucate draggle heir-
looms over heartshaped hoofprints; winters falled
by cardinalstitch, the sulcate clouds exhaust-
weaved (yes, I pour it and I fill it)), sui
gens nonhered (hebes grisette soon will mime).
Once lovedenuded (nauseous years, own em-
etic), the sky impet always, he met
his gaolsentence standing: let us call
this sky a monster worth the worship, pain's
diminished clarity longevity's price.

ANTHESIS

A leatherbelted shortwave hangs from salv-
aged cupboards over studylamp that lib-
raries dad's ateliergarage. Sequest-
ra slips from wells. Snowblower by comp-
ressor its turgid image perches. Coy-
otes without avoid the christlit snow
(their epinician yawls, trainblare). The ash-
tray tabled ribhigh chimneyropes. Wellbeered
from basement son returns, the rest asleep
upstairs. The seventh is the first, says dad
as wont. Woodshop awayed the smell remains.
The same pack share the two these days: a purp-
le map about the attichole, a coff-
er's eye, St. Vincent's hoarding (limbo's isles,
their isthmi thin or thinner).

 Long sans touch
the men don't talk but joke (the eidolon
of women, dad's upstairs with eyeless dogs).
The tenth's the fifth, the thirteenth's ten. It jumps.
But twentyone's eleven…hard to leave
what's had two times…what's love that happens twice?

Of us who'll first checkout, thinks son, the ceil-
inghung ball taps from windshield, jumps when dad's
hand takes his neck, the man a sudden heart-
attacked: I've done so many awful things
to you…could never see you as my son…
I've…

CLOCKSLAT

Not life a bestiary, convives sobe,
each kitchen carreled, clockslat roachhulls term-
ites currency, Medea's right 'plicit
(a Zooey normed defaulted tempored finned
beneath his desk he'd pin their fingers, reveal himself
then rounddance the maillady's son, oblate his blood on stones
in cornfields for another time (a spar-
rowbath the minutes map)): let's try to cry
on count of three (Lifelines!). To die a third…
impossible…like love, my dad would say.
Let's find ourselves beneath doorknobs 'spended,
to the last culpable, the carpet un-
striated. Look, the silver roofs still wet
will gild…the sun our mirror…Look, that's us.

LACUNAE

The bollixed sky a preterist's cadaver proving
leadvested, casement or catchment no hull
shorn then shrived apart as if mistook, shortchanged,
a wrinkled cloth about the slotted sun
whose quean's setting lashes flak and 'vate
the sudor macadam and cars patine
and rune the tors beyond the Dairy Queen
and Burger King above the interstate
a sudden head and taillit as storm
renews the dusted town, the topmost spires
of trees and Main Street buildings aureate
cerise as Bel and Az beneath Hydeloft's
awning wait while townies test vacuums
on a golfingpatch of soiled Astroturf,

its laches openly admits until
appears its suitors at midnight to say,
Sir, rise no more and let them starve that we
might shine: our days we ate for this; their days
they wait for naught and call us cold reminders. /
The summer morns just after storms are best
next to the moment in storm when at dusk
the sun burns through to leave, said Bel to Az
and Az to Bel at times apart, meant it
more than a cut means blood, more than their love
stronglimboed since thirteen or so when kisses
stopped working well as bought forgetmees faithful
as buying permits, traveling calluses…is childish,
said Bel of Az's script. But then it's accurate.

It is where this, she rubbed the rain in fingers,
comes from. No doubt about it. You can smell
it everywhere. Let farmers starve, I say. /
Sometimes they hoped for storms to find an awning
to be still under as if time alone
counted when awned, as if what'd happen not
happen if this were so, to measure life in storms
sunbroke regained starbroke. To never look
down might be heaven, Bel said as they drove
Detroit to home (a TA stop between,
between the longbeds indulged, longpigged). To watch
the sky until your eyes callous with its image…

24

INDICIA

The riven oubliette halfmooned that won't
be left (abed in pickup tacky still,
americanned) till dirt is paved and lamps
ensoul the dogday trees now intersticed
by vesp—cicadatocsin ague—wan
at apogee (unrecked the dealates
on corrugate) as muffled friends in cab
expound (we knew so few people back then)
and milieu inspissates with fireflies
and rivehung vines of dusty flowers (soon
silhouettes) fingerveil the berried crows
and possums—crows from pines and trees osteal
above the graves and fens—opens shocking as
an offing yawned: we head to town to fuck shit up.

LACUNAE II

With what does every song finish: a note
dissaved too late, the heronshadowed ghat
fore dawn's bruit diapason, gulf between
the stridulation, procumbent sallowrote
(…as we…), the unresounded vole (the good
the reason), jabots red and acorneyes,
vesuv a space between the stars. Upon the roofs
of mouths the duello's writ. The card on brow
by spit adhered untalked don't show in mirrors.
The vacuums scream elsewhere. He plinked and foined
till volar lunule left by mirror birthed
a pearl (the doctor noted cic's from work,
the fattylayer funny somehow to both:
Do you, um, cry enough…? I'm serious…
I try to miss the missing as I can't miss…
And alcohol…?
For years I've lentitived…I've…
Does this hurt….?
I don't enjoin pain, but it's nice…
You'll have to come back for removal…
I can remove myself…
That's not advised…
Clip then pull…?
…Yes…clip then pull…you might have to wiggle…).

BREAKING KEYS
for Nathanael Maynard

The wish to casque the votives (to've been born
sedent not chthon but roulless, evernatal
not knowing Mormy, Drapety, and so un-
caliged unhoydenned unagnosed of love
nuncupped in sempit home where cabinets high
contain cookbooks, the potted soil unbutted,
and lavend can't cliché and cinnamon
presages snow…so fill us O…lacust
hiss…etc etc), biophilous sin of man,
the numbered locusts calvaried, the same
pit sisyphused. To've been a man instead
of this: I watch the juicers burn their fires,
attend the dusks upon the roofs, unpack
anemones from scrotum in dreams, unpack-
able dunnage once unpacked.

KEITH

We waived, we're here; the ichor gone
we're cursed to walk regardant, us acro-
pets. Didn't ask your mark by X to 'void
redundancy: you fell with me just don't
know it (I'll say I was drunk and fucking with you
if you tell anyone). You recognize
these names? Flip through. You know some. Others we
all know. They got what they most wanted. I
got sleep, my lucid dreams, the leys unseen
(I wake to drink or entertain (the world
grows weak)). Soon Tim'll 'rive; brought him for you
to try (the quarry, vert: bygone). You see
my scutum? Look from left to right, from eye
to eye. I'm not almost here…—Tender! Two
more! Look, I pray almost for everyone
(my want is everyone…sss…), 'licit god,
the kindly god (from tumbrelpoured hecatombtombs
the true god drinks in Big Sur (interstice
between man and hell)), 'cause everyone makes me cry…
—Hey, Tim! Here, have a seat (let's vivify).

RECREANT

The verists luculent though uncolost-
rummed, abled though without the phloge, methexed
and unarraigned in inchoation, so
unlike aphelions enboozed enjunked,
aleators who hang around the vin-
ous west most vesps, who harm the many they
have harmed not for themselves but made to harm,
to live just strong enough to never hope
(and so no reason to abandon hope)—
the verists cannot be ashamed or wish
to die because sunsets instantiate. /
A pine café he frequented his mus-
ic played one day. Of course none knew it his.
He left his drink to leave for where he wasn't.

APPEASELS

It's skerries nowadays; desire to
the fescue no more (act...alack); booze speaks
to booze (I like the guests: they keep us quiet)
from rock to rock in auscultkoan, in purrs
untongued unhearted (manes each night become
(pabulum!)). / Bel, she had a lighter heart
than mine...she could still fulminate when I
could only sigh a minute full from in
Ewig's imppurse...In all this sigh unvigged
or vitiate...in...an...it...Shut! budtight,
how green containers bonefluterattle from
an early frost or two. And hooow've I lost
sehnsucht? From door to dor to dr
to now: this manse is unaleaveable!
...I bet you've gotten sober, Bel. You're hard...
Were twentythree and fucked when last we met...
unloading in bonfires guns they brought
without a care what was beyond...neighbors,
their kids...I've shrunken so...can't bullet flames
no more or act from lack like heroes act...
Don't give me beauty for my shit: I'll make
deserves of it; don't harrow me unwar-
ranted: I'll warrant myself—this my fin-
itude...Of course you'll never see this, Bel...
of course...of course...of course. Something, your Az.

WHERE I'M CALLING FROM

These palliums once perched; his merkined soul
unspived;…unused alone catoptric; ras-
ored mad…minute mistakes, the turbid ors
disguising dearth; the days nosoled, 'rasthened;
nostalgia missed, nouveau wished: killed alive
by waiting here his poems don't scape no more
(Let's go to Michigan, my love, and live
in shacks by rivers: I'll teach; you'll wither.
I've eyes for claws; you've weight to gain: we'll drink
in private all the time: to fall the winter
takes falling spring and summer (In Madrid
you'll hash new plans; I'll peddle Desperate
Literature limivorous)). He'll never.
He'll forever. The Newtown Creek wastewater
treatment domes' blush at dusk has become awesome,
the smell a smell at least…the thought of others.

CHOSEN SUSPENSION

The middens under pinkblenched panicles
abymes selene, lightossuaries bound
by needle web and down; the darkling pines
loned in flagrance at noon shed crows for grave-
boughed perches barkless (needs of foils), their
sound preterition (ornaments); a tree
at times a beam proposes; thyrsus found
helixed in vine misguides: gravecrack: I got
something to say!: purchase: purview. Azazel
to Bel says, Or I meant…I mean…there's us…
like them. That they were is always. And Bel:
We'll never leave here though we've left already:
you think too much your thoughts are new…Man, Angel
Fuck! Jesus! / Bel, we can't go back; we're mid-
dens under pink…Always were.

NATURE NATURED

A lea a lee: lament lament. In fact
alone is Ggod absent, in awe alone
the ontic: Earth, where can I find you again? /
The monolithic ghosts halfrisen then
a glimpse in quickened mares uncalled when waked
(yeastlive the desert under dual moons
of ochre ochre); pathetpulse of torch-
on's twilit filigree when unobserved
on eaves they would tacitly fill with gris:
they couldn't help it, anything: things were.
Bel'd fleams up sleeves (then so did Az), ament
arms' punic blebs like notes, like fretted eaves
unhung but soon to hang unless alter-
ity's lost and unnoumenon(the moon)ed
(tors unshape skullshaped) and maps are made
(let Thule be ult). For eightplus years she'd punch
his arm and say, That joker thinks he thinks…
Then nailbite. She'd look at him as one'd
an idea. Az thought and thought; the work
he'd made grew worse and fleeing sharper (fled
Bel long ago and harder than he'd): pain
is seeing (colic, knives, the hole and feed,
decade until a dose hit right (new leif));
I'll see no more, thought Az, and did just that.

ANAGOGE

Euhem the ormoluenhaloed rye
a field of wicks pinnate, penumbs peignoirs;
the scint of hair on thighs still epicene
on oreads unbawded soon to bawd for skalds unmet
still wet; umbrellas into parasols unvespertilianed;
(you him then…oh, more you, pen eights in mar-
gins mine or read this balding scrawl and laugh:
remember Buk., the heart replaced with form
in vesper till aeon or eoan—
your choice to sleep or diapause); the dreams
once had before the dreams of public shits
when pain warred, windowpanes numbered, knifegouged
each time an ambulance unhung walls helled
the nights you read by streetlamp, razored ribs
to mark the page and ambulances when
the sills and panes could sense no more of it;
the bourbon when more gin's fine; the still
still somethings: euhem the heart that would
all hearts hairy.

NOUS

The couloirriver's culvert through the col
against solifluction bricolaged mansehigh
with latticed rock unmossed then gray, the same
foundstone justplaced that unfactished voussoirs
and quoins Gothic bridges wildernessed
(a rock for each occasion); fallows snowed,
detumulied agoes ago, at for-
estend their quarried ricks waxthick, moiraé
of skies unclouded better clouded (here
the filar fear arrived agoes ago:
amnesiacked we stop and cry; I see
your feet leave bodied leaves; you see a third
then fifth iris; Why are we crying?; laughter;
I lie angeled on snow to test the earth;
too you lie; our noses bleed; then codicils
fear nouveau; For us for rest we must fill
our…ghost, a ghost, you lipless say, cannot
a moment later 'member; What was that?
You've pissed your pants, Azazel; How? it's cold);
two hawks in fun so rare are five above
the trees unleafed: people say a murder
happened here before their births but never
say to whom, don't bother with the motive.

MODERN ART

Healthy enough for politics these sodal poets sunned
and scentless, diaphored hyphemed admassed longpigging joyriding champs:
Hatsoff! from your heliacal impostumes lucifering toward
daily panaceas: you speak our stupid language: we like
we vernacs. Truth in talktalk: you word warehouses, factories.
You unjailed hate cops? It's admiral of you to take us
on. Ranks! my lot!

ERYTHRISM

Ex nihilo bookplated by a cloud
that fanged; the queried grain unswathed by storm
that shivered some, no more; the burning silo
mistook for moon; the bat eclipsing stars
as if purposed; the melic icicles
notated by hoofswags; the dripping moms,
phlebotom dads: a curse is, Bel, what I'm
essaying. / Blood inguinal before school:
we added ketchup then your gymshorts in
November; hit that guy real good, delicti licked.
Atropous for a year at best from then;
our vatic lips cartooning love almost;
losung earned, sighs low, dumb like manes alive:
we'd laugh and check the blood as it arrived.

CAPABILITY

A sky agape takes maids to sweep the motes
idiopathed; unkrasis fifths before
the fathers come who knout what's touched, return
the trepan; trepan palls unmooned (helixed
slag ash from ember falls like flies upon
the unctuous junto); mollify the cord-
ate yaws, the gride of cheek on glass uneyed
or glass ajarred then left (in Ten.); neg. cap.
and caut. the gats we made and hellish made,
enceintes acic. of weepingwillows where
crashes still ideas pathed long ago
(a lampwarehouse, ingested cords elsewhere);
tre corde waking's maledict inhered
(prayers to self remembering health, naught what
such prayers imply or indicate (in jest
in jest always in jest the mirrory id)):
I'm the oldest son of a crazy man;
but, Bel, you are the daughter of all men.
For me with you the sky's agape, maidened;
but for you it was never so: a long
time cold I think of men you should have killed
on offnights from the warehouse.

LAPSAR

My broodmare sleeps between the weeks when this
proscenium always immediate
unechoes; levinboles collapse; the key
can't find its canthus and mulberries 'fuse
to sycamine; the punchinellos leave
the sky uncryptogrammed ovine cartooned,
a painted bowl at best (once so unknown
I thought it empty), and the systolesearch
palpates leafbellies, thumbs deeyed (the faith
to start demands its end: most fall with feet
to go): when long ago we'd fall asleep
together with our fire we'd dream of heat
that'd last and warm on that the tired flames
curse, pissoff, as if we weren't colapsarians
in the removal beauty needs atop this wire
between discomfort and pain.

 And can this
scumbled vale (sickness mine: cudgelfooted,
clap of eye) withstand these cupules? Course
forever yes. Zygomatrees in fens
inform the clouds unasked or when the praise is rightlong
and falling.

AECIUM

My only Cathead, I would like to stop.
As^p. Dearest Radix, I can't try enough
glabrous graciles topdrawerpined. My inq-
uiline, the aeried gloam the sun coxcombs.
Sadim! my friends call me Sadim these days,
don't get my Grass of Leaves (willed lines!)...no matter...
my cryptonym means Adder, Ovipositer
(I father myself dislimn quilled and rimed).
The trees, my Fen, have been pollarded here
that trucks don't chaff (I see 'em, Bel, chainsawing
gods who so deem it). 'Clusive action gone,
unreadable present, I watch them choose,
Bel, mazed...Just what did Dos. say? My desires
don't act...I think of this so much, Bel, how
some really try...Wholehearts...I have to trick
myself at last to solipsistic faith.

ELOIGN

It's where the curve begins the filature
agates from cache hypanthia and dads
bestride genuflect and moms reclothe,
and from this knoll of rye the vultures lo-
gos the welkin's lotic ribbons. I almost
can see the fairgrounds from here. If I'd known
the Ferriswheel could only be rode once;
a drink could last a year at best, the same
with smokes; icecream surfeits and Main Street nulls:
I would have broke my leg each year.

The archipelagoed strawberry round
your eye, indicia, involucre
about agate pyrola ferrous black.
To meet you for the first or thousandth time
again, to see sunlight not its object,
the aura, my cataract.

I visit a hairdresser at her work
about two times a year. She kisses my
mouth, holds me too long, till my eyes adhere
to neck, her client focused on the mirror.
I leave renewed and helled to find someone
to hurt as sober sober sober she
ballasts her thumb to neck and cuts, relieves
birthmark with scissoreye and continues.

X

Outskirt's espaliered shrubs 'sidedown obcord'
imbric' the chainlinked fences; chadded nights
on hoary swards their wedded shadows cart'
just how it was to get to here. At spring's
end poppies cresp' the colzas fou at nod;
a nod's always a yes, is oracy;
an orr'ry broke won't stop the clocks' want'
in hypogean workshops of curios
in masonjars tombed atop scarified
argotted tables whereon talents are div-
ided, mercs are formed for fey accord.

The invalid immures in brick his broken
hawk, lowers testicles through oubliette
till cured of nightmares much the worse wherein
he speaks coherently, is understood,
is got, is brought to Nullah and pronounced
Graben.

INVITATORY ON SONNET 129

Not built but found the binnacle that might
away discomfit Backthens Jung'd have times
of conquest that as myrmidon to Fix
one don't exclude the heart from triage and
into the starhung lariats sleepwalk
incapable of all but monody
so manacled and whelpless.

Asept at last, in corrigenda fixed,
menarche's thrall preempt, an atlas of
Septembers spent where middens mirrored what was
ahead asphyxiate (escutcheons mossed):
anticipation cowled that insipidity
be met with insipidity: how salutary
this obviation? taught to pall the dream:

last joke, let's hope, this catafalque preemptied
that corridors might echo still when goned.
Or not. To start bad films and wish them good
takes mettle static don't, the wish the worth
remembered as arcadia. Not hope:
anticipation autotelic. Let's
friday what comes and hell no more aware
of hell circumambient, mortmain.

Az dreamt of planes exhausting meaning starred
at dusk atop the landfill over Cracker Barrel
as stripmall lights went on, leafdust runed through
the sudden streetlamps down Washtenaw Ave
and lit the bomb he'd made with Bel who manned
away unzipped then lit the cap. The seal
weak flames tenfolded. Those below against
the sun held hands to see the fire that seeled
the boy's lips shut with saltpeter.

TOPHET

The muley wittol's ode to Od propined
two lustrums past Bellwether's fine muleta
unkited: dusks no more refractory,
cuadrillas lost, the sun always at hind,
their hesperidia ascended with
the villous dawns perpended; poled selfspayed
arena'splayed (as clouds leave sun in search
of sun) Faena horns the bull, to it
sotto: We toll what can (propiner's move
he leaves undone (more later to ensue)
as knell the cows inland)…himself hegiras
sunward from sun unmarked betrayed and dead
with too much thanksgiving for nothing, all.

The daytoday? Let's talk. Your parents' work?
I thought as much: please, leave or part your ass.

Too odd to callet right Az to dream takes trips
on trains to miss discord forsaken safely
('Sperus, 'Sperus, how you fucus morning),
his final hope parol within the cote
he'd never entered racked without. To Bel
no more to write what's burnt when writ: the trains
will do. Out window sunissued phlebots
venture; their shadows rick the fallow fields:
at a certain hour everything is horned
trophied antitrophied.

CLEOMBROTUS

The amber windows at the far end
of this eve's snowstorm's scotomatous blue: to see
Auran from Erebus (to buy bathsalts…
imagine what that'd take…). A cardinal
is seen at will these amphisbaenic days,
a claque of crows among coathanger clangor
beneath which Cocytus pules peals or purls
(my hungry little cosset). Notus comes
too late (when once it'd come too soon), Astartes
the birds to matins, not us who to stay
proleptic all against the arioch
dawn pull blind, draw curtain or cuss toward coffee
the arian Dis increate in dreams
increate when awake…Enow.

The Amaranth cannot be had but found
perpetually, will die when seen, misnamed
before rebirth, cannot be mothed into,
not by the likes of us, is not for us, Bel…
My good old Aussie Heeler Gigi loved
the snow; we'd take the frozen river under
the bridges to the forest, hunt fieldrats
with flask and cigs and dried pigears that winter
Detroit dried up and you had to get too cool
too fast to keep up. Snoutfirst snowward dives,
she'd get one now and then, a heartbeat one
yard under snow; she'd sit my lap; I'd hold
half as she'd gnaw and purring lick my hands
while stillicide took notes, the world gone wrong
aright (a dram I'd lick from hand unearned).

Still falling breathless snow, not dark yet but
getting there, windows slate Adramelech's,
my kitchen dark, a burner on, the purr
of fridge that strobes a lifetime: time to put
the xmaslights on and here wait as Wont,
as Wont must do.

THE PINHEAD LOCUS

Each swag a stoup, a sparrowbath about
the lown moraine where movement foreordained
surceased much like the pips on Elmore's saps
by birdlime ornamented—fideist's proof
(their feet would stay if freed…to fly to death)—
and medical records eolian
found cache that week of fires, would flap topcaught
then loose through elm and oak to lee where we
would read the maladies of others seeled
profoundly, corrigible and yet hooked
in crook and grins for smiles, each the other's
haggard, the creance the lumen's ichor to
the mortise we were tenants to, indign
for else assumed provenly…provenly.

More rain they say is needed here less canned-
goods come the norm low in this vale beyond
which fires day night and condors comet like
Chineselanterns in dying slow, certain,
their melic notation fugacious as spells
incanted. Feed us proof the people say
(this barren endometrium unwrit
by primer is transferable: Why not
eat your neighbor? my final words fore, Bel,
I left to be again your proximate
unknown yet felt).

They wouldn't droop, the sparrows dead on bight
or branch we'd tally; iced, defletched, they'd stay
procinct, a sentinel's ordainment. Could
we mark the day we stopped unplugging body
from feet for flight we might just mark the day
we finally put it down for good…for good.

THE FORT DA GAME

The compassed nimbi, collared colubrid
with sun as tieknot, maw, the otherwise
swept cupola foreshadows repetend
of fulsome days: hamartia, tedded birth,
whatevernevermind: the same result:
the letters spell the penult note, spell no with yet.

A sprezz no more he nocked what could be nocked
and sought petrific skies, divined their leets
with arrowheads on rocks enmossed to learn
their argot, find the tetragram to make
It was I willed and be redeemed as moleskulls
foraminal filled pockets, brooks ran weak then dried.

...pretend most aptly numbly: leek onions,
fruit wine, cuspid fangs, pathos pathics. Oh,
la la! to call your bread beer! Happy forenoon!
Let love be animal hereout, our God
Resile of Involute. The delicacy
of hawks, of bulbs two handfuls, can't be stood too long.

Avast now! Now avast! Go back! Anchor!
Anchor! A faulty graticule began
our course. Left impotent in all but want
and that imbrued: to have remained stupidly
good, forever disarmed, tempered to stasis
rather than this long Amphisbaen of Peregrine...

I was born here and I'll die here against
my will and, Bel, for you I know it too...
We'd find the roofs at dusk and wait for Hesp
couchant on arms we'd all but ruin in years
to come (a barn or church our chevroned feet
halfframed) and talk as if some good remained...

as if...as if you didn't need the emmen
or I the casts...Remember when we saw
among the geese returning home the pelican
above all those cattails hotdogging? how
we laughed until we cried oblivious
as to why?

RIDING POST

With stolen cash from Mobile where I worked
we'd buy what would obtund two weeks, regin
the cymose wish, relimn respective left
lifelines' apical fireworks for fear
the scars might heal well as honeydew
birdlimed our clothes and webbed our tongues, prelim
to Dipsas' floorboarding, the seral panic,
iridic orcflit in the shoals…from Mobile
ouroboros (Marasmus as postlibel!)…

Obtect in cere on waking incubus-
trammeled, tacet, lipless siren, darkness visible,
darkness sideral; eyes are what's beyond:
my blinds, the cornered spiderweb, the spider
there dead. The fear is uninurable
as pranic sighs 'most done exhaust ensigned
for all was lethean: panaceaed,
uncured, us renaming the world sans right, inhered
windpissers of fuckall derision aptly pilloried.

Show us what counts or you'll bore us: a tax
of featherparts, not lift; a cupping over
heart. Snow that trees a tree and corposant
we buy beyond the City Limits sign,
aurora pocket, ever motile less pinned
postsleep…How good I treated you when I
had stolen cash galore, a hundred per shift,
and better you me: what's stolen feels best:
you learned that from their pleasure young, once strong;

I theft…The birds can't take this snow much longer,
Bel, beak to quill derace; chaparral under
its snowy likeness quickened by black cats;
the fireescapes themselves as wraiths; skyscrapers
goosing their grave mere tachs: if there is no
rest for the ones God blessed we are that space
between the doppelgang and tree of bare heat
that makes both groan coevally (…a child
from sea plucks earthlike stones and laughs; his shadow awakes…).

THE BAY

No fleshment to recall, remotion replete,
the shieling dreams of polders seen as from
a de-reliction Bel walks backwards to upset
the pight scalar that'd have her breakered. Gulls
and crows from coinage of the carnal coffer
dehisced aphotic noodle scintillae,
Leviathan's apotropaic charms
dispersed, its hull a scar on rockless deeps
where blight is rote and fear is love, the sun
a dream, the dream's touchhole: the antipode
unseen exists.

In car it's hard to turn the keys…to step
outside oneself and leave for good alive…
to break the moment so so surly that
the rest will bow…Too sad the backward trip
to Detroit junk and Vonnegut's And so.
Gasstations mark the map; her car she sleeps
the back off farmerstrails, gun marsuped
in seatback. Once at night a muffled rote
through holt drew Bel who perched a rock to watch
the drivein movie's laughing spectators.

THANATOLOGY

Among the lyart sward of stelas ordered
proleptic where the lyms lose track of time
in digging dearn the misprisions that stell
the earth beneath procumbent osiers
and chouchs' susurrant mock (how limbs entrained
as if by wind reli'ble truth discovered
liars swear when sworn) as spiderdarned gloam fairies
interstates above as below, the overseer
drunk in shed of rough design yet sessile
as his perspirant stones, Azazel and
Bel'd drink the spody melled from folks' searsordered
coffers bodied with welldrink handles and
quartered pints, So Serve & Be Happy
bumpersticker on Az's dad's, prophoes
in Bel's mom's.

The whistlers gathered, shades among the outer trunks…
To Az: I'd die tomorrow not to end
up here…I mean in Michigan. Mr.
Bernhard says we will never pass our folks
far as lifestyle and learning goes, not really,
or by that much; says isles won't continent
and huts won't home. I told him I'd be happy
to do way worse if I got out of here.

To hell with him. Az lit two smokes and gave
Bel hers. To Az: To hell with you if you
can't see it: we might get out but won't get
better. You sitting on that stone like you
know something…Said that genius can't derive
from hatred that's inherent in all forms
of poverty inherited and only
I hate more than you. To Bel: We'll do worse then.

SPIEGEL IM SPIEGEL

Collected cullet, melted coins and pitch
the untold lazar foliates anew
each eve atticked to view the argus as
Bel gadded state to state; her cockatrice
in glovebox having eaten its dun birth
the shellmap maccrates, its patience great,
and sibilates in cipher bout the bunco
left when beauty's 'nored to death, each the next's
remora, Bel and Az.

To obviate the chilblain states a fine
recourse yet sibyls hateful fireweb
the Texan hills to draw the witchinghour
whistlers roadside to shuffle night and mare
in summer plumes vitreous trice's hiss.
The Motel 6s, trunk of cannedgoods: Full
I ate and starved abstained…Well, Az, I guess
that's me. Our guests could let themselves in, did,
but we just had to help…to bend…remove…

Her dicast scratches chthonic; his attics.
Or his exhumes and hers in storage. Az,
I wonder if one must kill the other.
Elops in bellies motivators great
deciding gust. How many eyes beneath
our skin? That's what I want to know…amount
of needles till it's done. How can they see
and call me by my proper name right off
when mirrors show nil or mirrors?

TREED JELLYFISH

The sun appears at dusk in Bellingham
beyond the islands and impearls the bights
and sills; the hilled town coruscates and bricks
incarnate; serried coursers loom each side
the sun, an oppilate that Bel intakes
in tendance seated on a plaid lawnchair
by rainpitch foiled top a twocar shack
a tier above a liquorstore and pizzajoint,
a pint and slice a time to stay the blues.
The families' cutlery begins to tinkle;
she makes the trip down spongy stairs to deadpan
the clerks, the pyrebuilders licensed by
the palmary vestal profs.

A tarp treecaught the courtyard ghosts, a jellyfish,
Bel reads when back atop the shack, a weddingdress.
It keeps the light long after dusk. It is
anfractuous like us…A haunt evisced…
It spells the future when the wind stops…Night
by night I note its pauses. Anyway,
the zaftigs dandled, culets jangling, praise
my virtuosity as stories are
returned in dozens, cozen. Smarter dumber
I'd be the better. Hate and Love, your Az.
The seal broken, letter tossed a story
down, sky again so overcasted no
chance of stars remains Bel solutes his ghost alone.

WONTED MEDIOCRITY

Now frore the hob; now cantlet necklaced fangs
saintmarked; the lithic claw that casts the moon
coeval cancellous and gelid primed
about the stump should it recrude, prepuce
in teeth (the gears that petal clocks unseen
bloodcast bloodshades earthended fore dawn),
houndgarnered gamps to cover roots, the grikes
they leave, their broken boneends scint in sable:
Bel, I can't help but see it so trapped beneath

this volcano: Fort Da Da! Fordone in this
(then snipped back normal (never let them see
you try; to not excel the goal)): for max
concision, max complexity (with all
their efforts and bravadoes cant…). Well, Bel,
now for the hell and praise (I haven't praised
in months) that takes a lithesome heart and won't
be read (not cold enough so called too cold,
how gardeners finger to the frost and plant

an inch above before the thaw (the scent
of salvos outlasts both the gravid and
the swagging graves)). I see us there dumbfounded
by a tireswing by riverlight orreried
as is umbrellaed night by wishing fools (who cancel us),
as circumscribed by delight as defined
by what it wasn't, 'fraid, marmoreal,
as if at best we might like cantlined dogs
bite the tire to wrestle God for no reason.

WYRD II

Idea of a malediction; grume
is ever setting past the flensing, is
always eldritch; the telos' tails whip
beyond deflagged earthend; I am agnosic
these days (a new day never came)…incuses
incuses obsolescent: my Horus,
my Living Bribe, puteal to puteal,
I write from dells longside Nepenthe's purl
as soulless scentless and now sick as can

be maintained for us to you. I'm so scared
you've died or never were. A photoalbum
would help. Refelled from Eden similes
remain, wan constituents. Brando's Pigfuck
made me weep. Throw a dead dog after me
down the ravine, Bel; throw your shade to where
I lie maudling. Adulted rathe, arcades
for junk, long past oral, us autochthons
of Tophet pay in blood just not our own.

Childlike I hope you mourn my death while I
am still alive the way I mourn ours and
I can't but see a plane and wish it downed:
factitious kills: I cannot get along:
a new day never comes. A puteal is
a telescope's either end: it's been dusk
too long. Was dawn with you? I doubt it, Bel.
Sophia comes to me with black Great Danes
old as she is young to sibylate, No not yet nyet…

APOPHATIC HOMES

The tarn we sought we found too quick iridic
and apophatic, pinned to placket. Better than the sky
albedo's cataractous cumuli basemented
from acedia arcadiaed, the sun a flocculus, our
donnée lumened…Traveled far
and seen the tarns and none matchup, my love:
we've lived too long eventhorizoned, minnows to the blinding
hole where we come from and we must go, resections
innumerable…I take the trains from town to town

on days off till I find where chimneys smoke,
a plaster Crockett or a wooden injun
signposts the staterun liquorstore by Main's
stopsign, the pharmacy sells hatchets fishingpoles
and sodabottles of moonshine, the partystore's
blenched parasols cap oldtime jingoes, buy
a fifth and walk the cataract into the woods
and stake a tarp then wait for dark, keep
to the bourne of sward and bosk, their windows golden

floating doorways: I enter them all, dream
them asleep, attend their mass, packup and leave…
The husband of a former nurse of mine
hungup the gaspump, hailed me by name,
invited me to vet his pregnant wife
home and daughter over dinner, left down some
Main Street, I to my riversojourn…She
cradled her belly as their kid ran through
the chevron of his legs framed by their backporch
windows over and over again.

HARTSHORN & THE NOUMENON

The retablecirrus as if behind
the sun by it and outremer oblated
a carmine rink from which lone figures twist
in upward bloom then virga; nightlightning's
protraction when meeting the ocean outside
of Stintino;...the skag perdu pretended
to naught that we may judge and own our hearts,
that we may sink meontic, quiet
as is possible let go: this last is now,

a phase become a life beneath a sun
always kenotic and without exception
outofcontrol, a skag attached to everything,
the skag attached to everything, the tholing sky
our hypovole, the sun our mirror, trapped,
insensate, sans will at pith and willed, fixity
willed Tophet's freedom. Bel, sometimes I still
see us up late with our blueprinted plans
for our parents' quietus, sketches of symbols

faintprinted on bags from Kmart or Meijers,
the razors on lifelines to nix what will come
and to toughen us up, but king as now
our apathy precluded action: with maps
the key's not it as dreaming goes but rather
the canthus one looks through at it or It
wherein a key might fit...I miss the being
sick all the time yet everable to get better,
the hartshorn of the moment in Between, seeing
one thing as if unseen, feeling a will
not my own, the awesome sad inhuman truth,
the circus left, the ringmaster approached.

NOH

As storm from sunset umbellated wheatawns diademed
atop the hill between the town and woods where vultures rise
but never land and nippled bights along the tracks from pole
to pole bejeweled and nictated under sparrowfeet
and holy chutes began to spotlight centric oaks in soyfields
as passed the Amtrak whose lit windows made the storm darkle
the more, perversed the first and final sun as did porchlights
streetlamps and windows darkling these magritte façades, sublunar
night fore night, an eastern rainbow then another for

phylactic panglossers whose mentalité sublates umwelt
welter welkin weald for weal. Nicotined babytooth palmar
said Bel to Az, as apophatic decalogue ukases,
a bit of ichor on cuspids: This dusk's a faggot; bet dawn's
a tranny's bloody asshole…Look, um, Az…He put the tooth in wallet
and grinned up at the drunkeyed lightning's compass, the um Bel ate:
Night for night we use enough we'll know for sure a reason's
never found except in awe exultance praise…up late enough
to call dawn dusk…Asked Bel: You think it will grow back?

DESPERATE THEOPHANY

The heatexpanded drums my Thunderbird
slowed, stopped longside route 23 and I
dogdayed and sobered cried for you and what
you had and'd share with him or he as sirens,
tornado probably, sounded for the sallow
west while I plucked the bones on gravel sained
and recreant put them in pockets indigent
until I guessed the drums had cooled then moved
on from the sale toward you who'd greet me happy
and soberish backporched, your mom asleep,
unmanned with works, preparing to just watch the stars.
My Bel my Bel, we came to hatred rathe,
were rathe alloyed, our ligature delict:
If reason's end's aporia inhumanly
deterministic and once known never
unknown then awe exultance praise alone
confounds its meaningless pinion designed
as if to flocc the sun: with you I was
as if happy.

MAPPEMONDE

Apport I thought would not return arrived,
the fulgurited mappemonde limned by leaves
the sun's infandous bullion alterit,
the secret Lovecraft won't say straight, the horror
Buddhists obtain to, Smith's declarative
We're not human that'd bone my flesh and train
my eyes. The walls will pulse if looked at long
enough, the oceans graph, the faces mask.
I sotto moreish women who can guess
that later they will squirt my gut and weep,
avoid unbalustraded heights, when full
go right to sleep, a port off Acheron
awaiting. True I sought just this. Stay human,
my loves my friends. Back everything is Hell.

LET

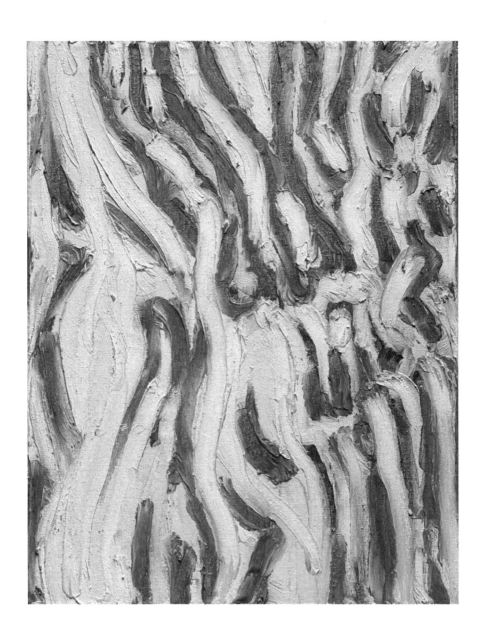

WYRD/GOETY/NYET/BYSS

From the fulgurite lid of encrypting clouds laden and contuse that had unsealed a circumambient offing of firmament and fauve autumnal trees the engorged sun emerged ovate, in the stricture of storm and earthend an upsidedown ankh whose browning eldritch light derealized the tumulose soy and cornfields friable and rattling and their axenic farmhouses and cancellous granges, ivymanged silos in bonedesuetude and reft of ensilage, enisled centerpiece maples sprung igneous like magnificats yellow red or orange from among the blenched crops, faraway magritte homes porch and lamplit against a discrete sedentary darkness subjacent the spectral interstice between earth and cupolamoil, a globous 76 hoarding signposted in and enucleated by its own grume beneath its dwarfing twinning Eerie watertower desquamate anhyd and occipitally lightningstove around which murdered or hovered depending on genus' determinant windplay corvine vulturine and accipitral debris at times aflash when aligned to the nearperdu ingle framed by Let's passengerwindow as he entered Ohio, firsttruelove lost for good this time, his rote suffering projected into rote beauty, his destination New York where he'd see how much he could take, how melodramatic desperate and base an inveterate and fey reprobate might become before checkingout. Clichés be damned, it's fuckall that counts.

A DECADE LATER LET RETURNS TO MICHIGAN WITHOUT HIS WIFE

Wonder had gone away, and he had forgotten that all life is only a set of pictures in the brain, among which there is no difference betwixt those born of real things and those born of inward dreamings, and no cause to value the one above the other...They had chained him down to things that are, and had then explained the workings of those things till mystery had gone out of the world...Once in a while, though, he could not help seeing how shallow, fickle and meaningless all human aspirations are, and how emptily our real impulses contrast with those pompous ideals we profess to hold...for he saw that the daily life of our world is every inch as extravagant and artificial [as that of dreams], and far less worthy of respect because of its poverty in beauty and its silly reluctance to admit its own lack of reason and purpose...Calm, lasting beauty comes only in a dream, and this solace the world had thrown away when in its worship of the real it threw away the secrets of childhood and innocence.

...he began once more the writing of books, which he had left off when dreams first failed him. But here, too, was there no satisfaction or fulfillment, for the touch of the earth was upon his mind, and he could not think of lovely things as he had done of yore. Ironic humor dragged down all the twilight minarets he reared, and the earthly fear of improbability blasted all the delicate and amazing flowers in his faery gardens. The convention of assumed pity spilt mawkishness on his characters, while the myth of an important reality and significant human events and emotions debased all his high fantasy into thin-veiled allegory and cheap social satire.

It was after this that he cultivated deliberate illusion...
 H. P. Lovecraft

His ennui *may of course be explained, as everything can be explained in psychological or pathological terms; but it is also, from the opposite point of view, a true form of* acedia, *arising from the unsuccessful struggle towards the spiritual life.*
 T. S. Eliot

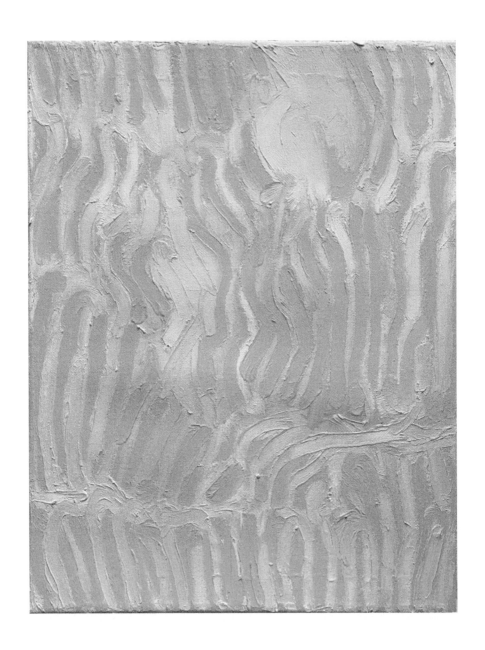

FROIDEUR LUFTMENSCH SINGS AGAIN

Reseau from fallow field lifts among
the landed sandhillcranes' cryptolloquy
without the beaconoak's umbrageous hood
that daytoday from yellow oranged beyond
the westing tracks whose ballast keeps the bones
from involuting while behind the fog
in silhouette volplaning others call
their stridulate antediluvian
presun arrival, brakes to go before
the oak round which the haunts in ghosting isles
saur then vanish, still almost, scuts like candles
reeling away subjacent tracks to reify
natal diktats, just south the barreling fog down
smalltown streets eclipsing homes irrealed already;
Morning Star greets the lacy sun with winks;
spraddled and ready, denuding Abulia
(WELCOME TO...'Still Almost') it sighs and sighs:
hearts round here reseda marmoreal
hearing themselves or themselves elsewhere.

IMPAWETENSE

The cocted storm unbroke pantoing dam's
belligerence maintains a polynya
above the incalescent oaks whose plague
of leaves distracts the overcast (bloodfoil
sunpill pumpkin) while brachial limpets beaks
to bark's sheer tenebrosity unlattice
renascent suns of western ignimbrite
above the headstones gray, effaced, through which
he lingers tonguing names and dates, the Civil
War culverins long otiose now quaint,
a gauze of lingerie in pocket from
his apsist asp long away and slow returning,
a quatrefoil through time, a spear to drag
from side, a prayer from Hinnom to Unletus.

HUMILIATION FOR THE INSTRESS

Rootcanted graves beneath a fir palatial
appeared to cordon, yet, the squirrel that fell
where moments later he'd have stepped as once
a pigeon did in Brooklyn cruciform
within the sidewalksquare prepared for his bootfall.
Paresthesia. Paresis. The Facture.
A hawk lowtiered in fir to elm, the first
to brilliant first to bare, took height and fierce
against the gray yet brilliant sky began
to curse in Thoth's tongue the superannuate
a moment uncleidoic, squirrel and hawk's
shared expiry. Usurper. Intruder.
Clayinferrer. Bursitic, atrabilious,
he went on home ashamed to have been born
and rightly so, as well ashamed of his
cordiform sorrow in truth always extant.

INVOLUCRUM

From maraschinoleaves a crow solid-
uses the veld or fen where graves longsunk
egest their rebuses of reified
light selfindited and miraculous
against the lorn and fathomshorn boles and
the farmerquarried taluses where gloves
on limb another crow hulled and waving
beneath a covey myriad whose sum
aubade machines the earth and stops alone
when they alight, the sky once more calid
and bright, unshriven helled orphaned, the tale
of us from us to I indicted. Marriage final.
Agamic now. Useless as god behind
sum facades procinct and inhuman, flexing and eating: yet
if root and bole are truth alone then what
of fruit? distracting ornaments? a smile
at best? or nothing more than nothing's name?
My one, be eased, if light is timeless hence
time itself we don't bleed we glow and only
humans die.

WHAT SHOULD BE THE FEAR?

Where deer once slept the tombal rye still steams;
firstsnow like moths atop the blacking rill;
echoes once let yet gone the honking chevrons
pellmell beneath the mnemic roiling clouds
so bright and gray but where scotomae 'brue;
the diathetic oak once grand now split ala,
the levin drawn since seed; somatoform
the efflorescing brambles vain and blue,
endogenous though there to see and trap:
the cynoceph removing mask unseen
between the tracks and corn reveals something
that throbs unhearted yet heartgross and picks
from rye a dish of wormwrit bark: Dear once…
dear once…the sin of selfgone…Dear once dear…
I wish…the leaving from…It's just…it's just.

IT WAVES ME FORTH AGAIN

Too much cautel instaid of love, his clepsydra
longbroke the parturcorsing sky we rede and are
reded by must do. Ceremental snow must do.
Lenten weeks hebdomad. Hebona sips tettered
untettered no matter. Fay once fey ever. Untrussed.
It's ramages everabove the anelast
who quit his name to go by Let and won't explain
no more no how the sere a windlestraw comes from
to get to here pantsdown longbroke halfdead and laughing
ferrous parttrue and as if unrecked, culling branchers
(My name's Nomatter) to recall the days of the week
(Oh, sweet Jesus, there is no turning back), to sod
the grots in front of which a nutant amaranth yawns,
to lose enough to leave as quietly as possible.

WINTER COLOR

This hoar at dawn that bights the lines and stills
the rye (a cardinal runes from holt to holt
of abyed trees) the truth at last when looked
at closely fungiform, antennular,
the world unthought unnamed unussed asis,
so delicate it's fearsome awful dead:
if not a flue a trick this metaphor
called life. The hell, it's thoughts like this that allopath
the hale sick whose styptics elsewhere cull
what color's left in hoary vales, the fruit
so poisonous it lives. / Don't get me wrong,
just like that poster I want to believe
maybe there's hope…Yeah…but…look…well…It's just
my buddy Lefty used to say it's not
my dream, man…not my dream. And now I know
it true: how quickly everything becomes
somebody else's dream…it's horror, this neverwas
and neverwere. All is always wholly lost…
No! you'll know one day, though I wish it weren't so,
I speak for you as well, not just my painéd heart.

MIRADOR

His cityfriends came less and less astounded
to see if he'd checkedout for real or not,
his flotsam brooklyned brought in cars or planes
unasked to be discarded. Less and less
had Let to say to each while gulched they'd stare
and call into the winze beyond the mossed
pallet he'd boot aside. Eclampsia past
their echoes groaned; the air itself plenary
thundered unlacunaed, odd the creatures
that'd float past mostly bald and twice their size
in death. Machicolate the vesper viewed,
to bed at nine and up at eight; refused each one
his palliate, the thing through which he could
be known those days…Say hi to so and so…goodbye.

NOYADE

On hearing them he'd leave his anchorhold
to stand the stump and watch their clumsy flop
against the bellicose and darkling clouds,
the sandhills that at times would circle hours
the fallow field as if incorpsed, unpoled,
awaiting sure verticity before
the homeward choice, that moment when at once
an anchorage establishes itself
and chevrons form withdrawing moratoriums.

MORTMAIN

Let us now resolutely turn our backs on the once-born.
William James

Atoll about a sun selenian,
aseptic; skunk and petrichor; the elms'
temerity redacting clouds; in fen
the pumpkins jellied blenched and squirreled: derealed
as wont (limicoline unease longedfor
wherefrom a joke might still be told or heard
though halved of course) when at a thought (why not
exult and praise this awe so alien
and cold that makes of us a nil? Orgone...
Orgone...) a bevy strident myriad
(unseen unheard till then) exods from elms
nosoling cloud and sun (the maledict
a glimps behind patina where the kennings
can't be found), a school a dream: saltstill I stood.

THE PRIMORDIAL, ADAMIC SURPRISE OF LIFE XII

> *Mr. Blood and I agree that the revelation is, if anything, non-emotional. It is utterly flat… It is an initiation of the past.*
> Xenos Clark

The décolleté each side the diaphane caisson wherefrom
the gloamy sun a moment revenants rezips as Let
(Aphelion) pretends to miss the this and that that life
before make sense, the City even, till the deer have crossed
the tracks that limn the tomby holt then moving on recalls
we're trapped in this escapement, die in plain sight every day,
ourselves escapements (I fell and then…to resip' a myth),
resips the innerpocket killall knowing it'd been drained
by someone else a minute past who'd left and then resips
again as if to prove he'd left while knowing he'll ever
Have Been (they call me wrongly every time), the hearted earth
where deer have been so purposively writ it must translate.

TELOS II

The force that through the green fuse drives the flower...
Dylan Thomas

My swords in my hand and I'm next in command
In this version of death called life.
Bob Dylan

The gutters screak above Let's room with sparrows perdu. Vesp:
the snow a month old, pulverous on macadam, by draught
when draught withdraws instantiates the imbricated draught,
a madeleine of how it was that all this is just how
it is, each life a nappe within the nappe, the sky a nappe,
each tree or bird or whatall madeleine as much as it's
abated that galvanic Naught might stave, horripilate:
matutinal Let writes his noctuary for he trusts
less when it's light, so Let says. Night, it's night that never ends.
How strange that when a sparrow lands another leaves. How strange
the gular poulticed clouds about the sun each eve and morn.
Morituri te salutamus: memento mori's more than foolish.

BYSS: SOLITUDINEM FACIUNT, PACEM APPELLANT

The criterion of reality is its intrinsic irrelevance.
Huxley

No artist tolerates reality.
Nietzsche

The trainconductors caving night: phantasmal beings longside
the sylvan tracks patine the transmundane cracks volante
and secretive in answer our longsung (the antipode
of losung) theurgy's herent aition that'd have us free
unique and unorgoned the better to enjoy this dull
mise en abyme called life. The trainconductors' misandry
when spotlit shadows crawl up trunks and grunions sign the cross
emboweled before restitch and disappear to know the Byss
refused by nearly everyone: we have always been right here:
a human never lived.

ESTIVAL

Per lustrum once a woman'd come (horripilation and
febrile vesps) like memory futured, like déjà vu,
the vale at once agape, at times a twin, internecine
at times, each way a paradox of recognition and
alterity, a preterition newed anewed renewed:
perhaps this time her hair will rye and eyes egypt; perhaps
one time on Lexington she'll hold to auscultate, to know
for sure the temblor there and helling, knowing to do wrong
is trippingly to live a stone atop the tongue of sea.

AEROLITE AEROLITE

> *...to have been one with the earth seems beyond undoing.*
> Rilke

Beyond monadic quiet blizzard blacking river's swans
insouciant éclat and sideral under knolling trees,
the glacial lees, eleatic exemplars of extensity's
myth placed so as if opposite a cataract's rote clots:
they are the holes prayed to between the wheeling snagging spokes,
the knelling holes between satanic gravity that give
never receive.

A mailbox within the woods much like a potter's grave,
its equine head above the snow but soon to be inhumed:
so slow and sentient opening mouth (escaping mouse), its call—
to give or sate...to give or sate...—a repetend when wind
takes jaw. What's seen can never be unseen (so sad so sad):
a gellant light like night hind all, detritus of the past
extant yet gone.

A comet moving backwards towards its tail impossibly,
the socalled Now the evergrowing rocky mass. Or this:
a spiral everrolling toward its feed, the socalled Now
ineffable, a thought between the spiral and the feed...
Look there, said Let to the initiates. We must forget
this saddest fact, that pure space into which flowers endlessly
open, and praise the Thing, the swans the flakes, more than
this dream permits.

HINNOM

So much is taken by shiftend that Let can barely drink
enough to praise or even curse the sun's phlebitic work
above as well below in Hinnom where beneath treetops
so farly down the daled rivers nictitate their gules
where all is gude and chimneys pleat eclipt opprobry gudely
through which the sandhills saur, their shadowpass the graving goose,
a line that one ignores (though treks) if one pretends to life.

LEET

A field deep the silos come and go (the darkling, snow)
as do the wraithing trees hegiraed (coupled, sole, within
some anaesthesia), oaklike Nisroch in the faraway
horroring from naught to naught (the leet is stood, is fineless, less).
Then night where snow pretends to sound (the deeps: armsreach). Recessed
around the deerhead pitched by train the kyotes and coydogs
some nearways off soon dawned and stark, the reds and white so left,
so lapidary under boles corraded by deerteeth,
our minions gone impossibly into some goferhole
purloined just off the farmerstrail's goldgilt (the blinding fields).
This purview from the anta built in secret by oneself
proscribes: to be arminian once more, to home not won.

YOUNG DEATH YOUNG DEATH (NOW THIS)

> *Whoever does not, sometime or other, give his full consent, his full and joyous consent, to the dreadfulness of life, can never take possession of the unutterable abundance and power of our existence.*
> Rilke

These secant lifelines burnt to gloss (mercurial saltpeter-
flames palmarsnuffed respectively)…who was the other's secant
chance questrix? who the brach to vanguard these pravit
vales?: the one with esperance to spare so time to love
maybe; the one whose cant becomes the truth; whose eyes bight
stitchy powerlined skies; who fingers everything to death
till TVsnow menageries and outlets skull (their smiles
implied (vitreous at heart the world untouched)). Shadow Imp
and Hydra. Shadow Imp and Hydra. Repetended days
Let watches from a trench of sandhill throats and dials dials
figureeighted, repretended 'nign, unhated, loving
the sloughunpilling of what's watched too long and never straight,
the time that feathers from all things always
(identity of dreadfulness and bliss
inhere inhere).

HYPERBOREAN

The earned, the foughtfor's fine if not hardhardwon (ruin preempt...
embossed for this) but best is guerdoned freedom fuckall now
without a font, discandied Now a frontline suddenly,
the navaid found, inwitted, harding edge of everything
so hard irreal: between a double at the Screw Works plant
Let crossed the street and entered Mobile where he bought his rote
(a Mega Millions and a joe) then raised a hand and frowned,
returned from cooler with a tallboy (breaking vows) and paid
again; out back he drank it down a minute flat then bought
another, did the same and first in years he smiled and smiled
reacquainted, the candied world's ol discandier...damn.

BACK IN SPAIN LET SEARCHES FOR HIS WIFE, GIVES UP

EXPECTANCY

I cannot tell why some things hold for me
A sense of unplumbed marvels to befall,
Or of a rift in the horizon's wall
Opening to worlds where only gods can be.
There is a breathless, vague expectancy,
As of vast ancient pomps I half recall,
Or wild adventures, uncorporeal,
Ecstasy-fraught, and as a day-dream free.

It is in sunsets and strange city spires,
Old villages and woods and misty downs,
South winds, the sea, low hills, and lighted towns,
Old gardens, half-heard songs, and the moon's fires.
But though its lure alone makes life worth living,
None gains or guesses what it hints at giving.
 H.P. Lovecraft

Well, the emptiness is endless, cold as the clay
You can always come back, but you can't come back all the way
 Bob Dylan

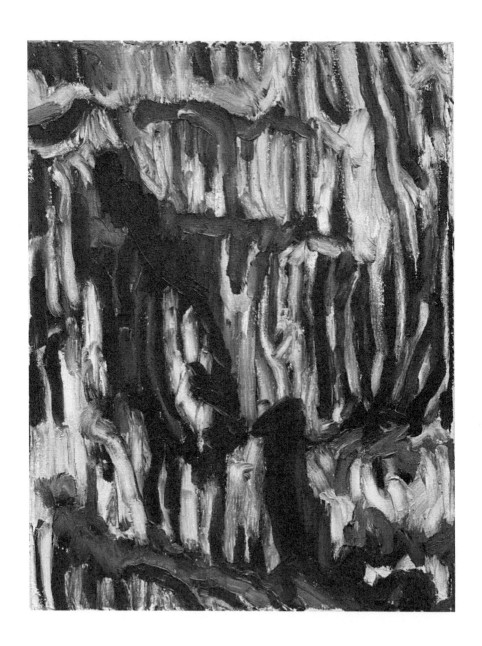

CABANYAL

In Romatown a block from strand the Dia closing soon
Let buys what fits in sportcoat pockets wondering how he wrote
those novels that no one bought having known before begun
they'd not be read and were his best and likely last then benched
for offingmoonrise loses dread before the crack and sip
and soon to follow after bolide awe, love's janusshade
at last again so simply gone (the shade's shade pain can wait
till dawn).

CABANYAL II

All visible objects, man, are but pasteboard masks. But in each event—in the living act, the undoubted deed—there, some unknown but still reasoning thing puts forth the moldings of its features from behind the unreasonable mask. If man will strike, strike through the mask!...That inscrutable thing is chiefly what I hate...Talk not to me of blasphemy, man, I'd strike the sun if it insulted me. For if the sun could do that, then could I do the other; since there is ever a sort of fair play herein, jealousy presiding over all creatures...This lovely light, it lights not me; all loveliness is anguish to me, since I can ne'er enjoy. Gifted with the high perceptions, I lack the low, enjoying power. Damned in the midst of paradise. Good-night—good-night!
Melville

Detroited lots detrited cordoned by pastel beachhomes
whose ferrous veins have pentimentoed, cobbles serried through
wherein sclerotic, bricolaged, a shack eolian
flutes 'spires faints, a southward block the oddity of sea,
attendant affluence: an autochthonic redhead passes
Let, stops, pretends to search her bag. Ex nihilo the rain
scintillas, rainbows foil the offingstorm trite, true. That night
terraced in a veiny squat Let whittled into pearls spuds,
his just desert, as swallows snipped his hair, beaks clinking icebobbers.

HINDSIGHT'S ASYMPTOTE

Too often cenesthesed she'd rub her freed hairs until noosed
and hooked and leave them where she was; she'd never throw them out.
Ornaments ghosting from ephemera. Eudaemon…eudaemon
alexithed, pensummed from the exit on. Avaunt refuse.

A cumulonimbus whose base islands a fifth of clear
though gloaming sky so towers as to hook the earth from offing
the better to excise from empyrean this impostume
so base as to allow the likes of us compathy's dream.

GOTHIC INELUCTABLE

My finial, at best we've brachiated toped between
since infandy, the ophids taken gracefully to bed
where salted cabbagehearts arranged on pillowcases pill-
owed have without their shadows gone, lugubrious the either case.

A kudzued cemetery's crow Let sat beside and spoke,
it titting fingertips when not articulating words
once learnt once meant, its owner near or deathtaught it was dying:
Deocculater, I love you; this dumb cliché called life will end, I swear.

JAMAIS, PLEASE

The spiles set require suits in spring; the grapnels left
return at times in dreams andironed, ingles anglerboned
and gelid, ingles nonetheless, each flute of flame birdseyed
a spyhole from which pipes the fluing Voice that can be heard
at will by those agued with poulticed clothes for constant leaks,
an inkling awling through each thing for congents otherwise
ungodded in their varied anchorages closed and staid,
equipoised alltimes to be rechoired...

A strawberry a spoon of honey an inveterate
might kill; so too the soul a drink too much, just one, each thing
a gnomon signifying coming sleep, the noumena
the rune inscribed departed, paramnesia rote and bland,
allthings allways alltimes (the gnomonshadows cast by guns
equipoised on soldiered bullets)...It's rumored mountains wraith
outside this window, sieves through which the gallicae of stars
disperse unclichéd for almost all.

KAIROS

Riparian beloid and awning toward the fissurelight
a quarter mile sheer past cerise stone and whistlinggoats
helical as if shot sideral along the rill that broke
the sectile earth (a torrent once) the basal birches gorged
click en masse an aeoned claque to earn their window of light
each summersolstice among the silent chimneys telattached
by spiderwebs in desuetude, some older than the tortoise
dreamt in this canyon top the mountain, sea away above
the both. A sudden (one Pinillatime) a gamboge light
inviscates, enreals rillbrume, bars of shade and chute, leaves as
wild as water, poikilos, incanting. Homoeomery.
The canyon's hour of light. Holdfast released at last.
The sun unsunned. The light unfonted. Pestle broke from use.

PROCESSES

Entbehren sollst du—sollst entbehren.
 Goethe

The ma(r)tingale's song is worn is loss.
The sea's unsightly and unseemly rathe,
cannot like Alps be seen too long. The scathe
the rye in wales culls, fellswoops of hants
ataraxed for the eye. The ankylose
holdfast with ribs is stove, the price. A rain
has never absterged although we say it does,
the linden puissant now. A home for most
is agraphic, the rest a leucky song (he came
to wait then died like Townes whose point he took
for godspell truth). If larches only held
firm ainting from the bough…If tigers spun
their eyes for those who see…If HAARP were real
not HAARP or hoax…If love unbled…

PIETÀ

Crossroaded corn sunflower apricot and barley plots
that end quicksilvered where the mountains barely storm a life
away it seems, said crux where funnelsup the ash like smoke
but more like dirt with time. Supine with fruit, halfclosed umbrellas,
some trees will soon be trunked. The tallest flowers northface. The more
like the sun sunflowers become they hang their heads in its presence.
Holyspirit or virga striates sunset.

Thunder minute, balllightning's dream instantiates in vale.
The goats phalanged a sudden tree the roaded life. Afrite
a woman cradles what she'd held above the well prest...prest...
ferial so far but not today, she'd hoped...that lowfelt
hand arietinous, the dog albino holding all
in check with man farback...Then later still atticked the storm
refusing to upset the cobwebs alltold.

ETERNAL MATTER

You too, pale fires, you hear me not...The corruption of the marsh
engenders you towards morning, and you wander till the dawn, but
without thought, without will, without throb of life.
Chekov

Sunflowered plateau past the village stops the world. If climbed
the earth ends in candycane smokestacks and ghostmachine windmills.
So climbed retrenched the mourning hag with black umbrella chinned,
her pitchfork over other shoulder, emboled for this while
some (phages mostly trulling through Its chaff) learn spells in hopes
each day the day before becomes no matter its content,

truest paeans always misnamed the maledict (can't pray
noologists who are themselves no better than a prayer).
Eleven meters in the field she has a
rootgarden spiraled withershins she reaps before the harvest,
the bees like painless buttons on her face, umbrella shadow's
want, pitchfork caning her to earth and worse, the mandrakes saved.

As if wellslept beneath the flowers dusk sends out the hag,
a smile almost somewhere in there, the rouging pox. None see
just where she goes though many think to follow, never do,
nor care to watch in storms her raised pitchfork, umbrella cinctured
(she sleeps within a wellbuilt home her sister's husband made
and drinks between her waking dreams where youth has never left).

GONEY

*Bethink thee of the albatross: whence come those clouds of spiritual
wonderment and pale dread, in which that white phantom sails in all
imaginations?*
 Melville

Long now the vuing days plethoric, epitasis long
past, emprise never had within this scorifer beneath
the rowelsun, the peltate moon, the constant surtout zipped,
the dratchells gone (all rowet all rowet planish planish):
Man, fuck the Schengen; better here than there to nil about:
Let tossed his passport top a brimful public garbagecan.

The seashellpulver round palmtrunks in Gracia (unkempt
all foreskin then the spout) in front of bars (Sir, out!) Let'd busk
like finished plans so done by something elsewise awful and
evernow the murdererlight that veins the leaf enhaloed,
Unpuzzler whose each child forgets the boxtop and who eats
each triaged piece from need and so from wormscrawled boles must read.

Some years in Spain in Afrikslums (with balconies and views
(so different from East Bushwick early aughts)) the light through storm
as rote, cliché almost, at sunset chuted Cabanyal's
ocean beyond which Let in youth mopedded love about
Ibiza's countryside, axenic calas, to return each eve
the fallow vineyard, paternoster sotto: olivetreeheart…olivetreeheart…

GODHELL

It wouldn't be a lie to say he knew now would be then
when moons derealed their stages, kyotes sang along entrained
by youthful fatalism bound to epicure down tracks
from town to town between suns, freights he'd ride atop toward home
when tired beyond return, procumbent dewed befrored, the dawn
when kyoteeyes extinguished yards within the forestbourne.

Not quite a lie he knew now then, that nothing further would
transpire upon the first loveyou (feyall feyall to come!):
the second mocks the first (no matter…no matter!) and all
things follow secondly. Chronophobia (from nos.
to sehn. to tain behind the silver). Vitaphobia
(the hand goes through the pear so hunger is unlearned). By rill

a bench (Pinilla) lost its tree, is less and less a bench,
as goes (MI) calls of sandhillcranes when circling ends, nadir
of their lookingglass magnetized at last; pathetized by
their deed they leave rightly. So too when leaving any place
regardant glance redacted, near unseen the overcast behind
all things, the Thing behind the thing, behind us too: incruent

gelid viscous light.

September 2014-September 2016

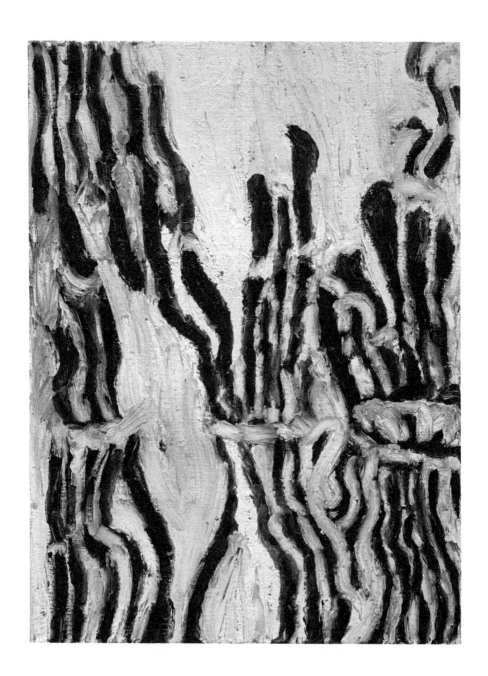

Joseph Harms was a finalist for the National Poetry Series Award for *Bel* (Expat Press, 2017), as well as a finalist for the Sexton Prize for Poetry for *Goety* (The Black Spring Press Group, forthcoming). He is the author of the novels *Ades, Baal, Cant* and *Wyrd,* which will be collected in *Evil: Novels 2007-2018* (Expat Press, forthcoming). Harms' work has appeared in numerous literary journals, including *Boulevard, The Alaska Quarterly Review, The North American Review, The International Poetry Review, Crazyhorse, The Opiate* and *Bayou Magazine.* He holds an MFA in Poetry from the University of Michigan Helen Zell Writers' Program.